TO
..

From
..

Date
..

Tips To Bring Your Coloring To The Next Level
First of all, pick coloring tools:

You can use pens, markers, pencils, or crayons. Choose whatever you like in terms of texture and feeling. If I would do recommend, here it is. I'd go with pencils for beginner. If you are wanting to play with some advanced techniques or detail work, then go with a set of pencils and a set of markers. Then of course you can throw in pens, crayons, lead pencils, and more later.

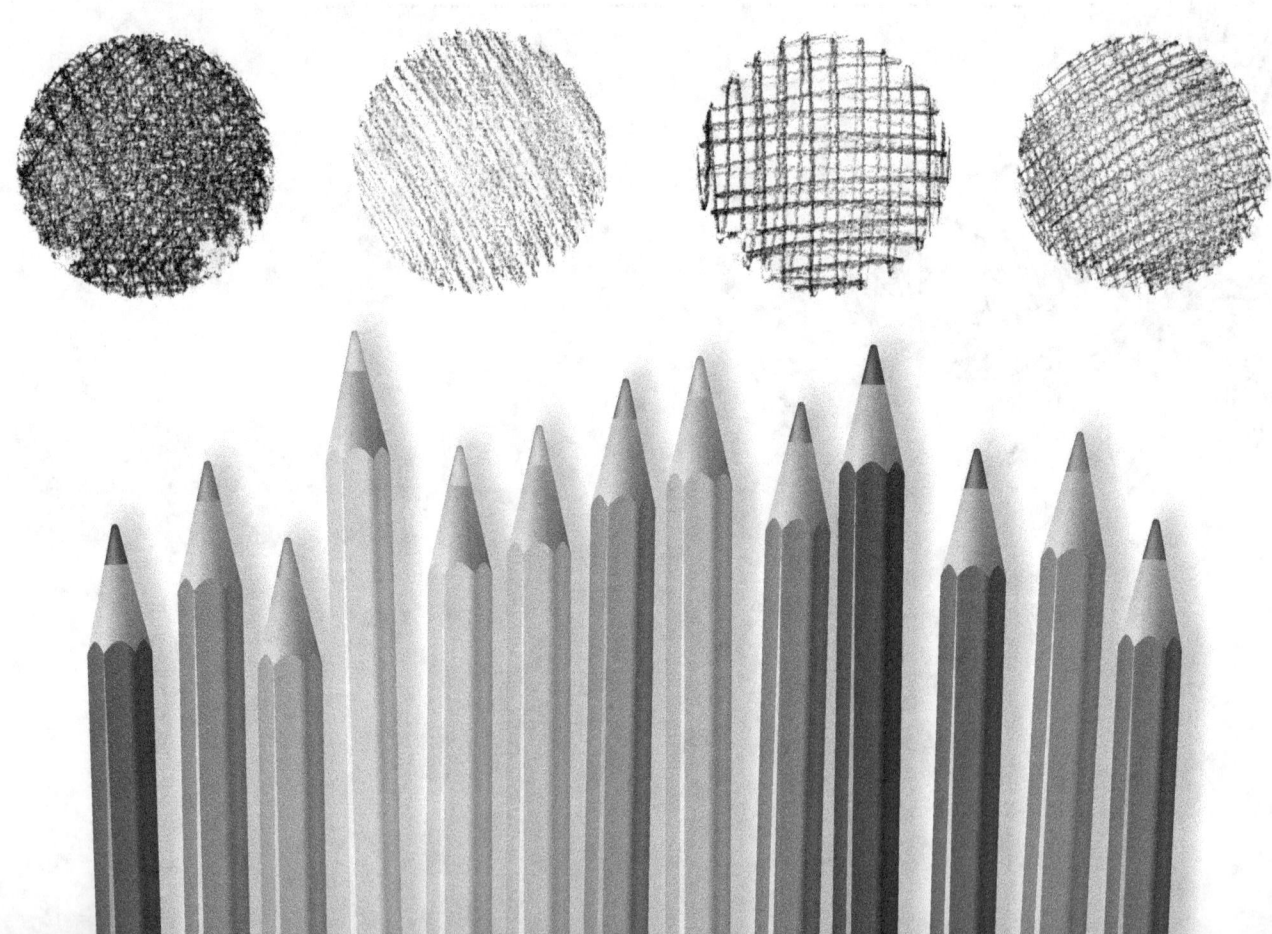

Palette/Theme or Better to pick a concept:

Picking color palettes is not easy. I used to spend more than an hours to see professional talk about this. Thus, I recommend making it easier on yourself by using available color palette online. You may search it very easy from Pinterest or use design-seeds website. You will get much more idea to make your artwork great and special.

Finally:

Just do it and let loose. Coloring is an effective stress management and meditation. Let coloring be your calm and have a great

Note

Note

Note

Note

Note

Note

Note

Note

Note

Note

Note

Note

Note

Note

Note

Note

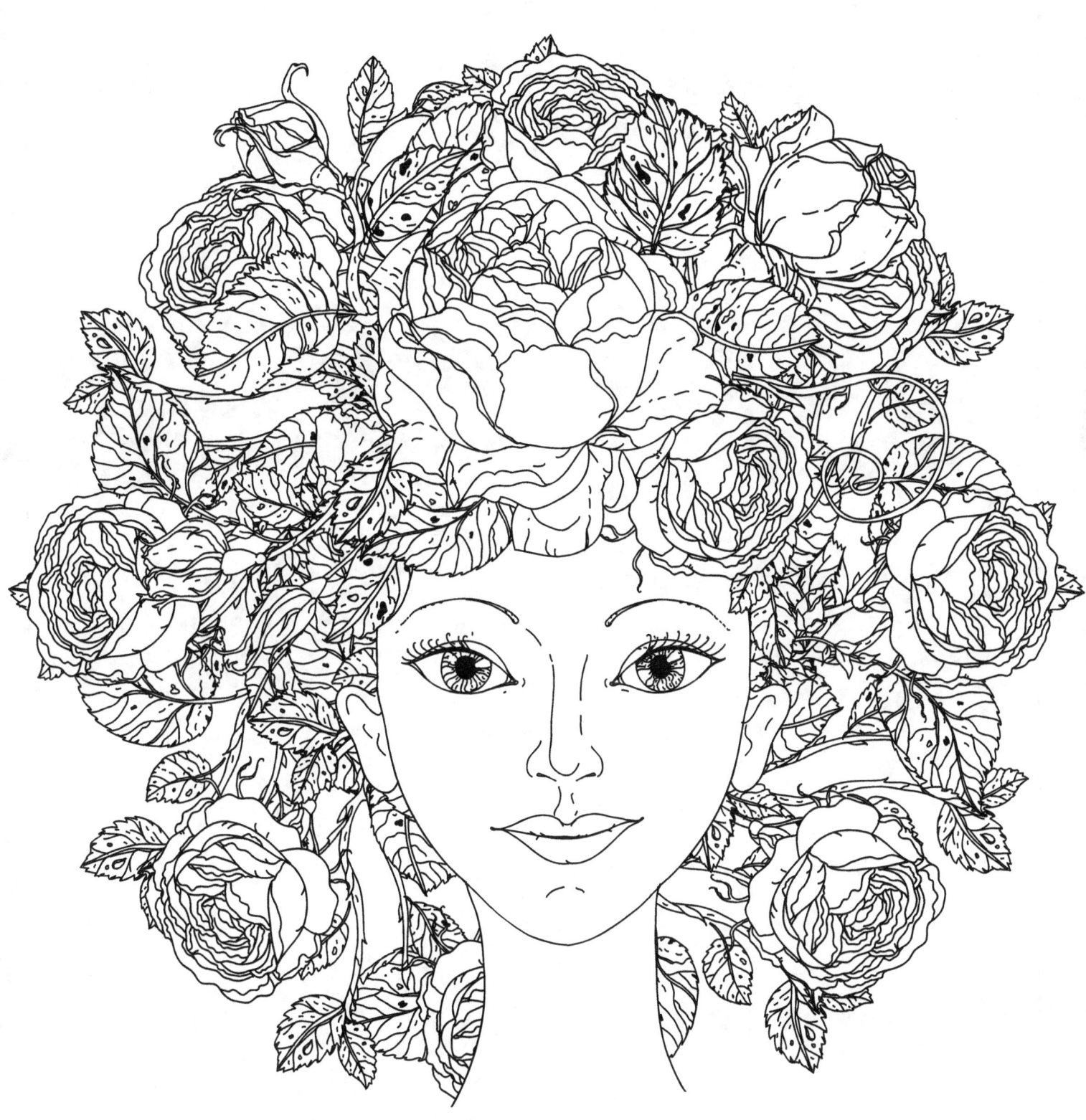

Note

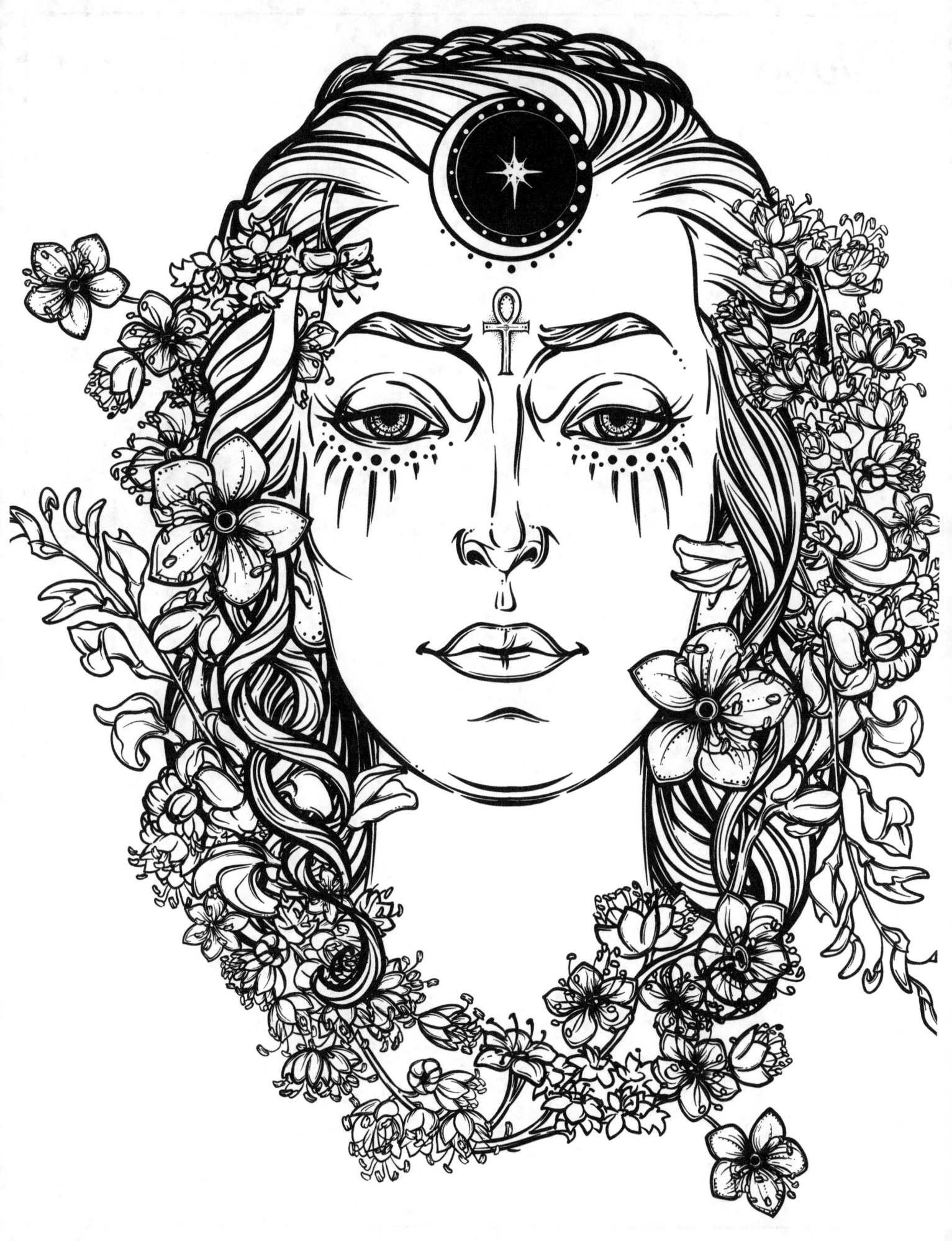

Note

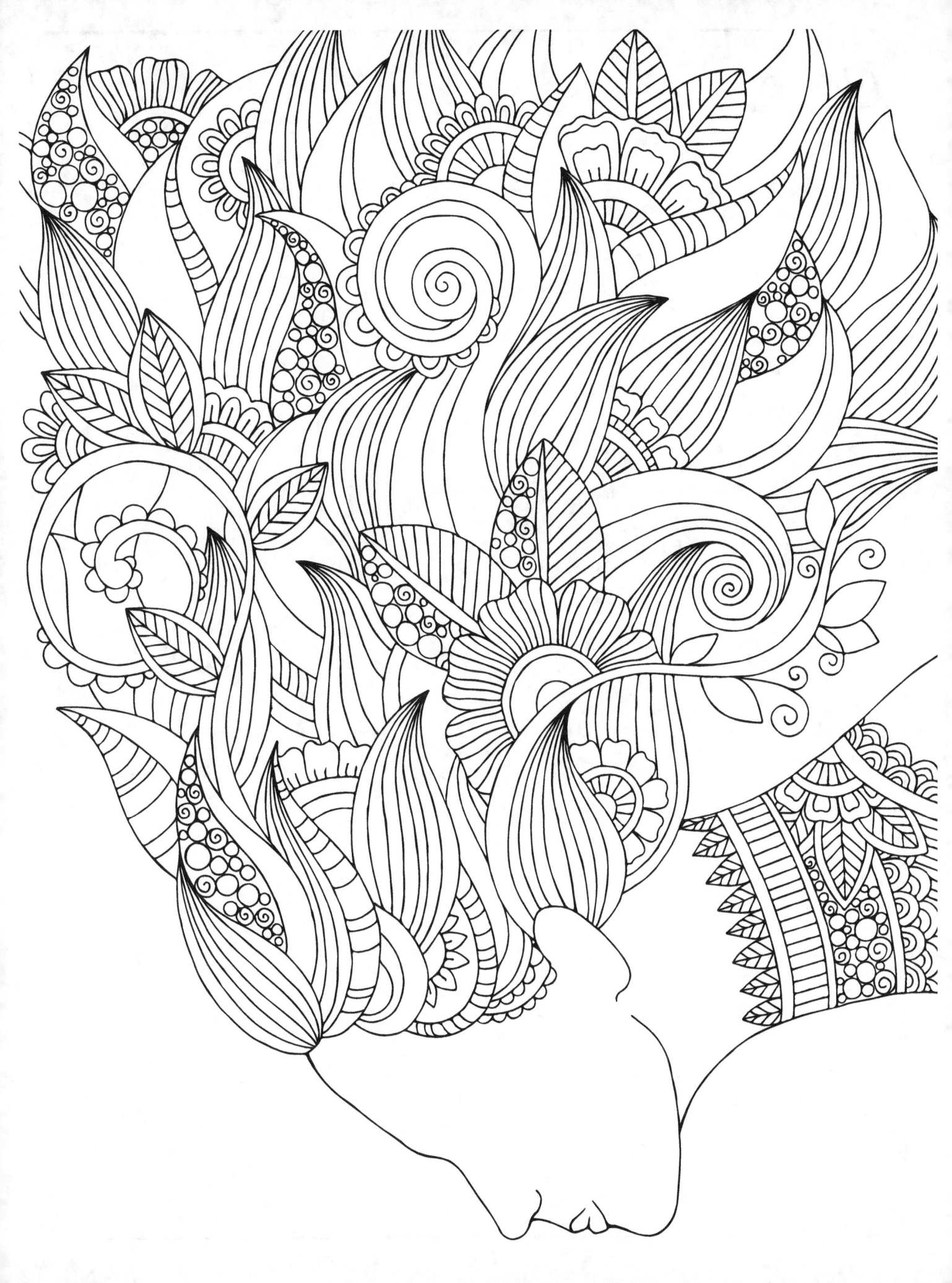

Note

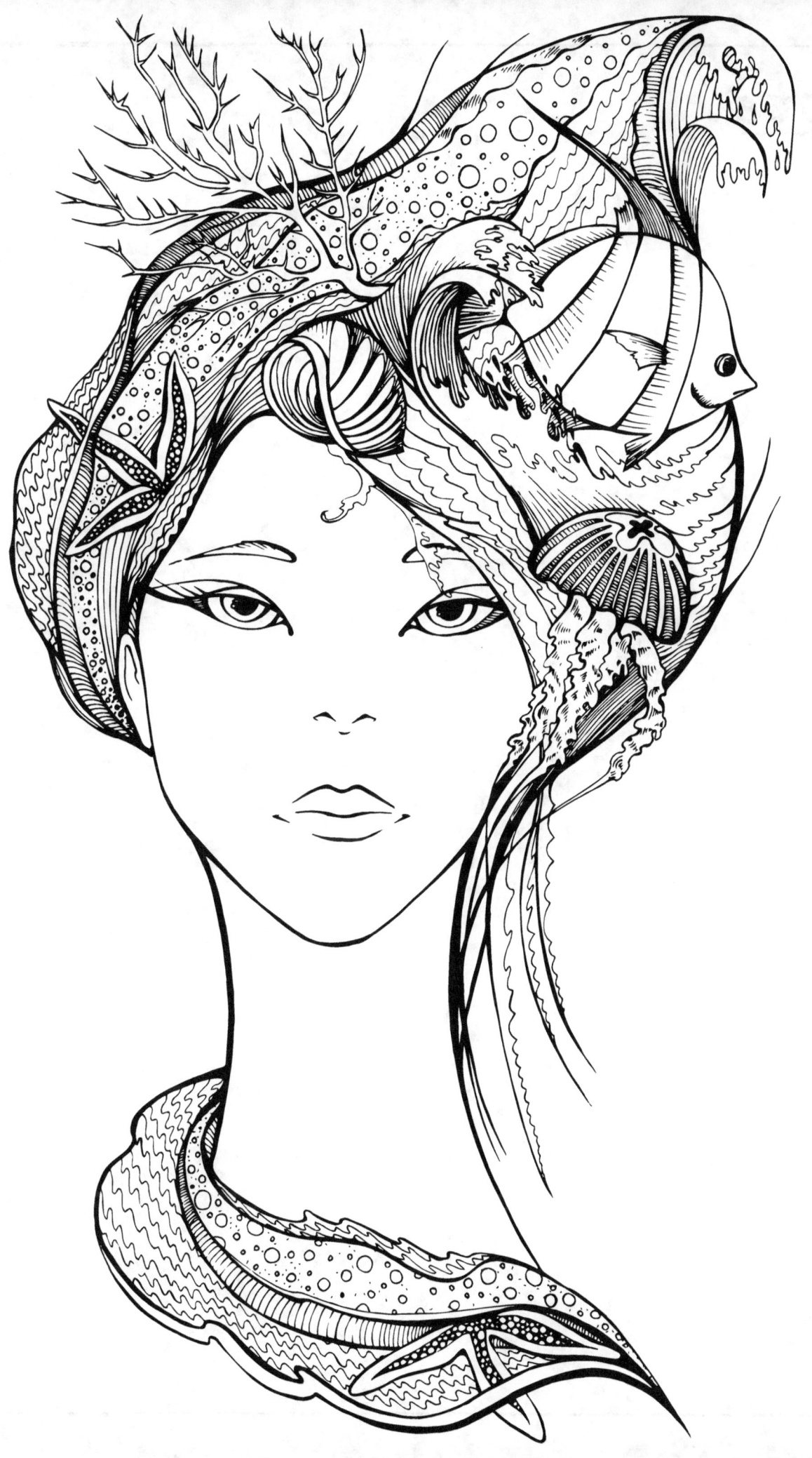

Note

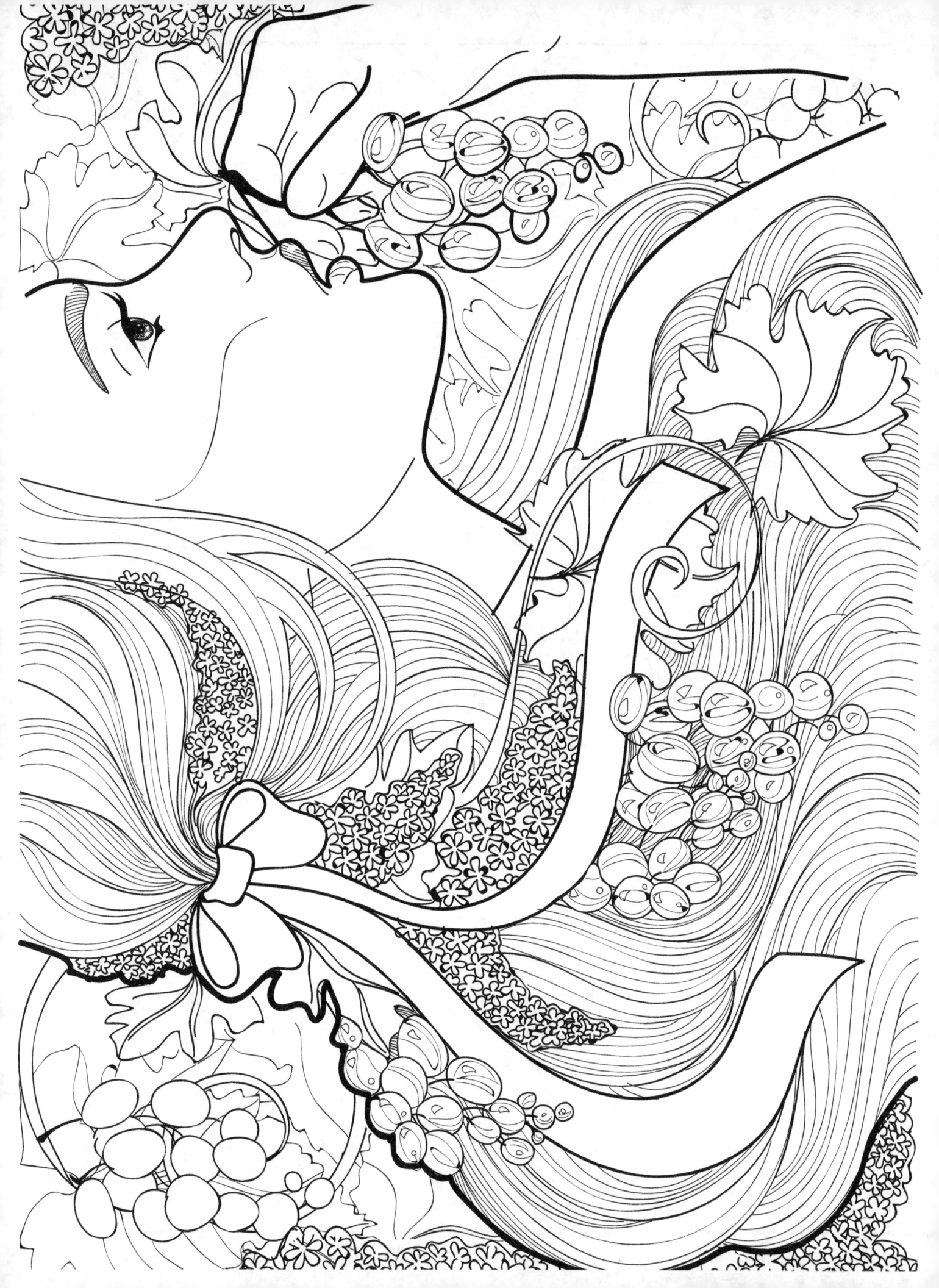

Note

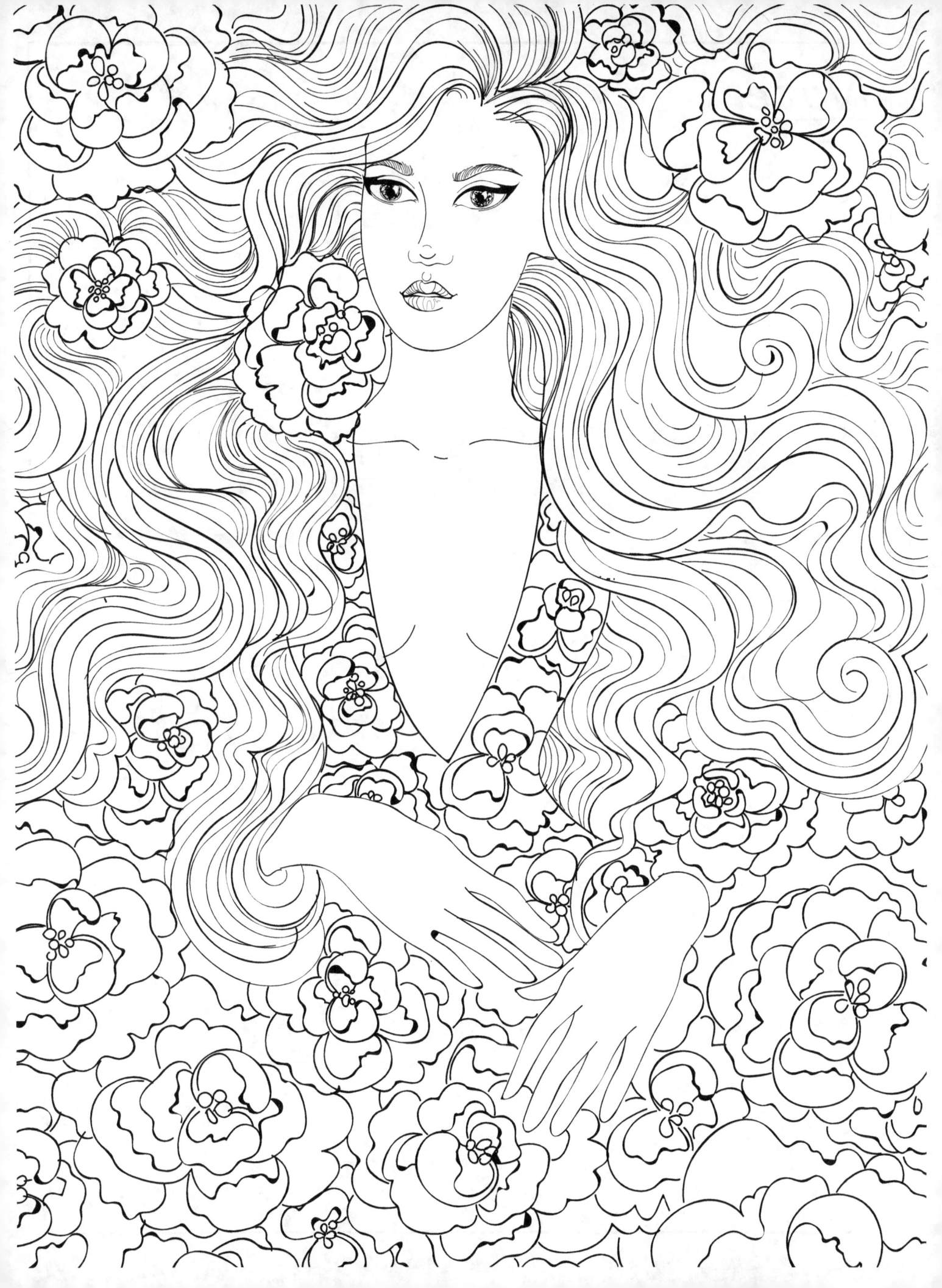

Note

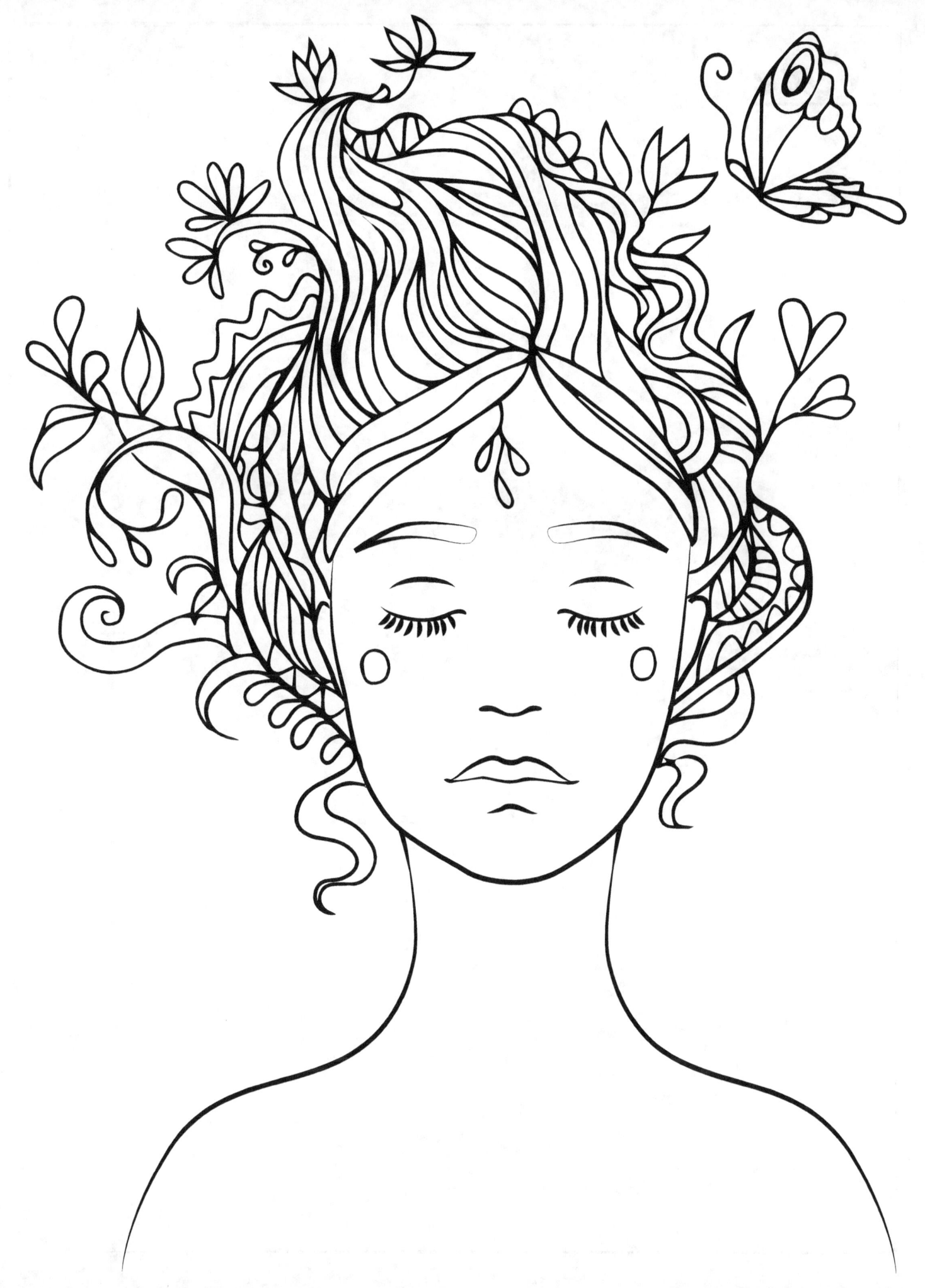

Note

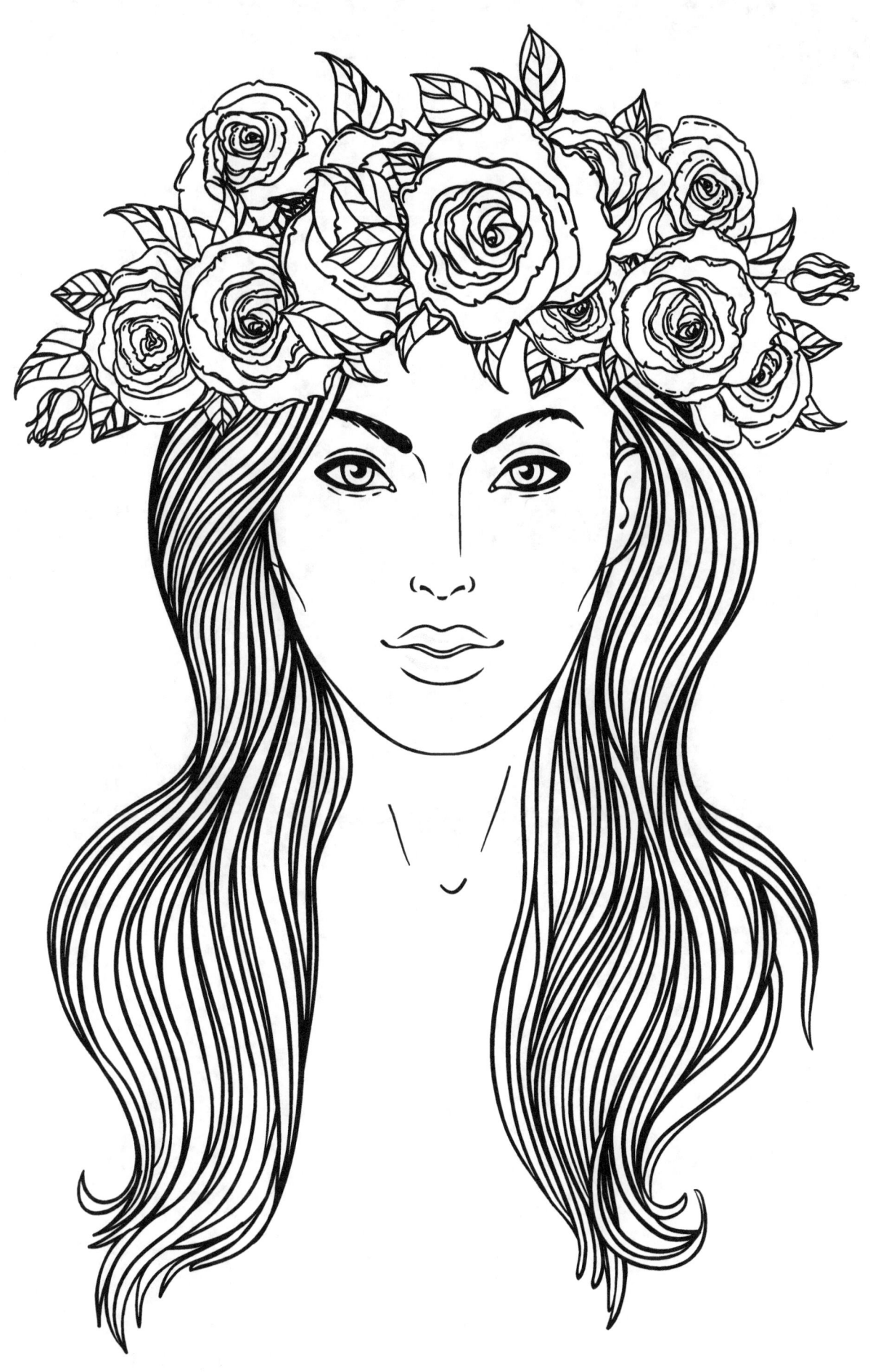

Note

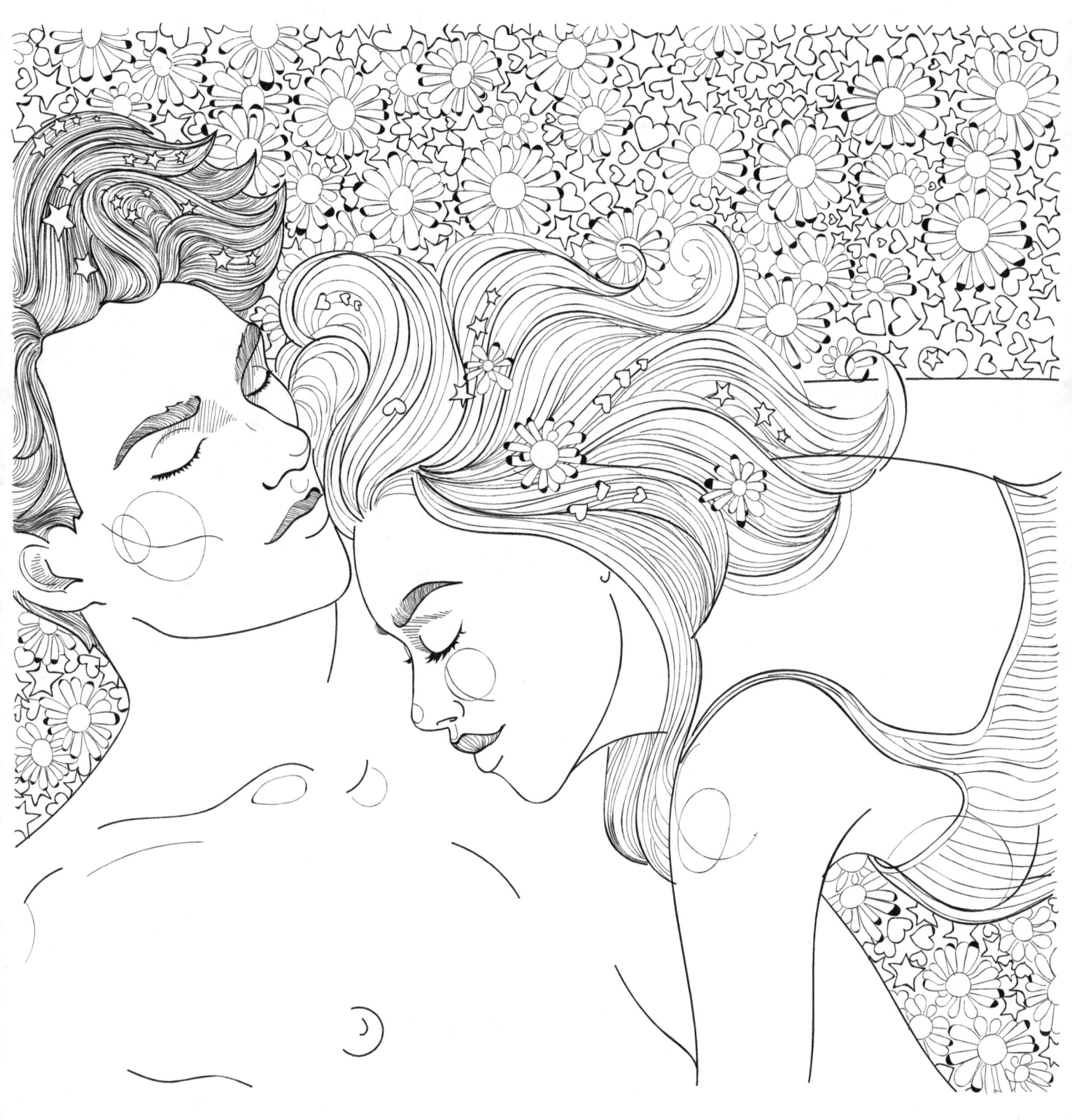

Note

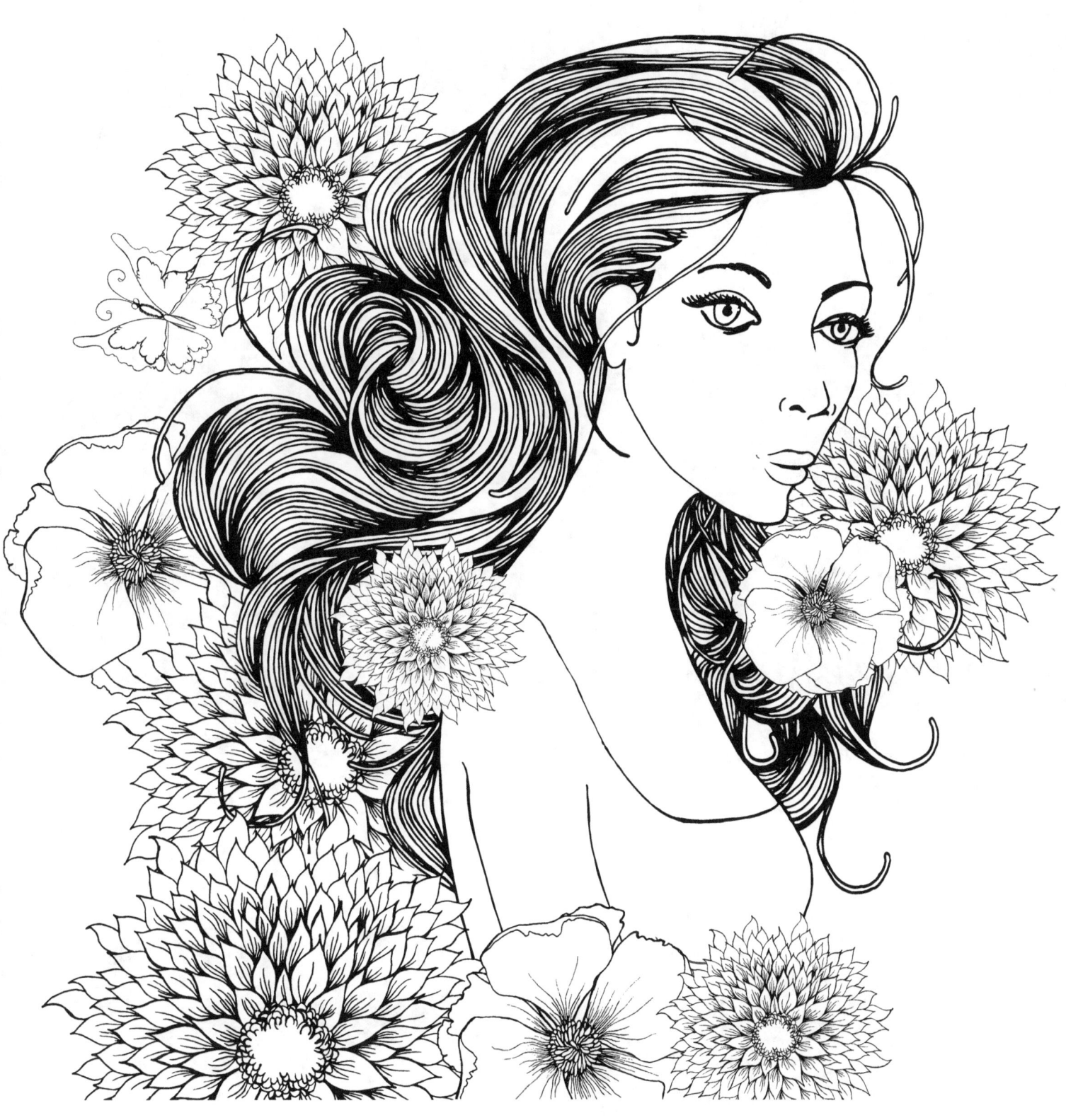

www.ingramcontent.com/pod-product-compliance
Lightning Source LLC
Chambersburg PA
CBHW081130180526
45170CB00008B/3060